An opinionated guide to

LONDON
MUSEUMS

Written by
EMMY WATTS

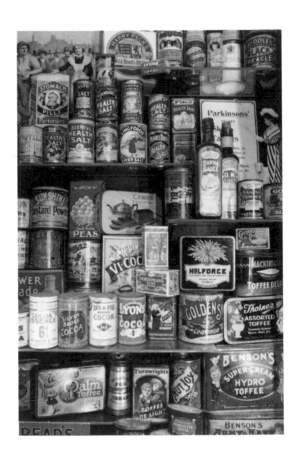

The Museum of Brands (no.43)

INFORMATION IS DEAD.
LONG LIVE OPINION.

Surely this book is pointless? Why read a guide when you could go online and find all you need to know in a fraction of the time?

Because information is cheap, but smart, reliable opinion is not. We've trawled through all the museums so you don't have to. We know where is best and where is the rest. London is bursting with exciting, immersive, playful exhibits – all you need is an opinionated guide to tell you where to go.

Our opinionated guides

East London	*Big Kids' London*
London Architecture	*Art London*
Vegan London	*Free London*
London Green Spaces	*Queer London*
Independent London	*London Delis*
London Pubs	*London Hotels*
Sweet London	*Historic London*
Kids' London	*Margate*
Escape London	*Brighton*
Eco London	*Cycle London*

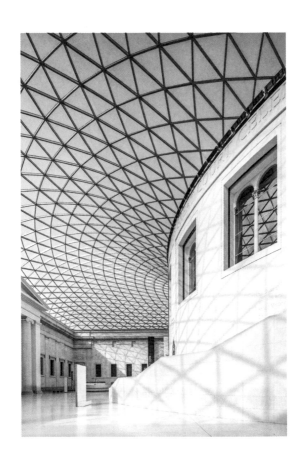

The British Museum (no.4)
Opposite: The Design Museum (no.37)

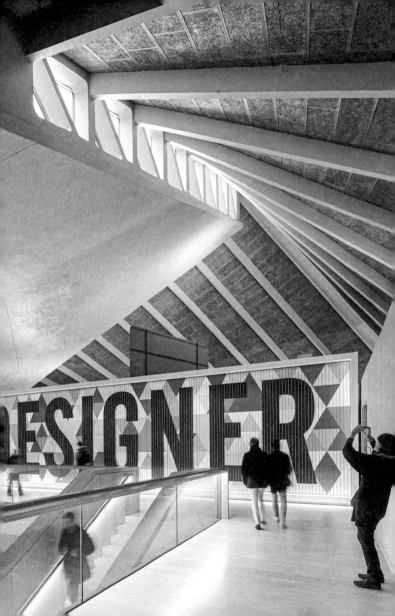

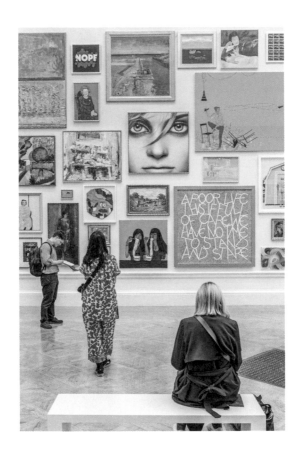

The Royal Academy of Arts (no.41)
Opposite: Hampton Court Palace (no.26)

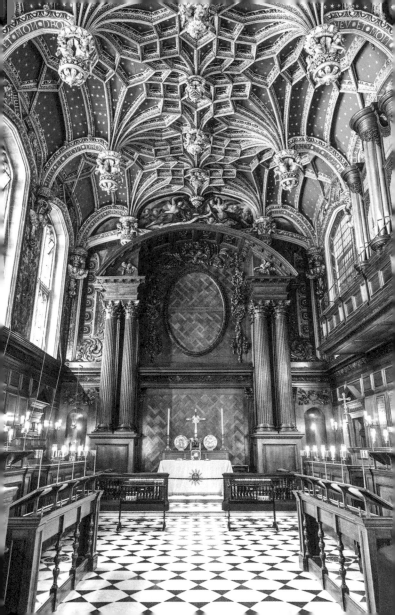

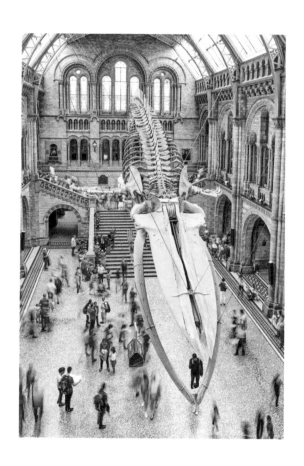

The Natural History Museum (no.38)

MUSEUMS AREN'T EXTINCT

(even when their contents are)

Why visit museums? You can Google anything you want to know and do a virtual tour of a historic house from the comfort of your couch; the days of traipsing around long-forgotten relics in dark rooms are over! There is no doubt that modern technology has transformed museums. This is a brilliant and necessary development, allowing a wider audience to experience everything our museums have to offer. But it is also no substitute for seeing things in the flesh – often quite literally.

While many of London's museums are famed for their deceased specimens (stuffed, pickled, pinned or otherwise), the museum itself isn't as obsolete as you may believe. It's never been such a good time to visit these magnificent portals to the past. New technology enhances our visits, with audio tours, hands-on displays and state-of-the-art immersive experiences banishing the clichés of dreary artefacts languishing in dusty cabinets for good.

Museums connect us to the past, teach us things school never could and, at the very least, give us something to do on a rainy day – but they also have the capacity to trigger profound emotional responses, whether they're celebrating humanity's remarkable scientific achievements (no.44), laying bare the unimaginable horrors of the Holocaust (no.20) or simply giving us something to chuckle about (no.6). They allow us to contemplate what it is to be human, from learning about our fleshy insides (no.1) to exploring our mind-boggling

insignificance as a tiny fraction of our planet's 4.5-billion-year history (no.38).

But the best museums aren't just mausoleums to the past – they stay firmly rooted in the present. In the wake of George Floyd's murder in 2020 and the Black Lives Matter movement, Hackney's Museum of the Home (no.13) not only changed its name and moved its main entrance away from the statue of slaver Robert Geffrye; they also launched a residency project with social justice charity Voyage Youth to explore sensitive and educational solutions to the statue. In the last decade, the capital has gained an LGBTQ+ museum (no.50), a Museum of Migration (no.30) and even a Vagina Museum (no.17) – all founded to amplify the experiences of historically marginalised groups.

No museum can claim to provide a fully comprehensive picture of its area of study, nor can any city cover every subject or represent every citizen with its cultural offering – particularly one as diverse and sprawling as London. But with the capital's ever-growing repertoire of niche and exciting exhibits, there's a real sense that we're getting closer. Passionate about propagating? Head to the UK's only Garden Museum (no.33). Fanatical about fantasy taxidermy? Try Viktor Wynd's cabinet of creepiness (no.16). But whatever you do, don't underestimate the importance of these temples of culture (and *do* exit via the gift shop).

Emmy Watts
London, 2024

CONTRIBUTORS

Emmy Watts is a Yorkshire-born writer who has authored or co-authored six other books in this series, including *An Opinionated Guide to Kids' London* and *Big Kids' London*. Many rainy days spent entertaining two young daughters have given her a pretty good handle on the capital's museum offering.

Hoxton Mini Press is a small indie publisher based in east London. We make books about London (and beyond) with a dedication to lovely, sustainable production and brilliant photography. When we started the company, people told us 'print was dead'; we wanted to prove them wrong. Books are no longer about information but objects in their own right: things to collect and own and inspire. We are an environmentally conscious publisher, committed to offsetting our carbon footprint. This book, for instance, is 100 per cent carbon compensated, with offset purchased from Stand for Trees.

BEST FOR...

Grand days out

Excursions don't get more majestic than a trip to Hampton Court Palace (no.26), the sprawling home of Henry VIII. Or go in search of ravens, Crown Jewels and ghost stories at the 1,000-year-old castle complex, the Tower of London (no.12).

Family fun

More indoor playground than traditional museum, Young V&A (no.15) will delight kids of all ages, while the Postal Museum's (no.8) themed play space and Mail Rail ride are perfect for toddlers. The Horniman's (no.22) hands-on exhibitions and aquarium also make it a fail-safe family favourite.

Mates and dates

Viktor Wynd's Museum of Curiosities (no.16), with its sordid displays and upstairs absinthe parlour, is a quirky spot for meeting a friend or a date. Or head east to the Brunel Museum (no.25), whose candlelit rooftop bar and atmospheric tunnel shaft tours make it ideal for romantic rendezvous.

Something different

Try artist Stephen Wright's wildly eccentric Dulwich home (no.31), Regency architect Sir John Soane's relic-stuffed townhouse (no.7) and 18th-century surgeon John Hunter's gruesome compendium of anatomical specimens (no.1).

Being moved

Hear the heart-wrenching stories of the capital's abandoned children at the Foundling Museum (no.10), uncover the history of mental health services at Bethlem Museum of the Mind (no.36) and advance your understanding of the Holocaust at IWM (no.20).

An immersive experience

Dennis Severs' House (no.19) offers total sensory immersion across five evocative floors, while floating time-warp HMS Belfast (no.27) invites you to experience life as a wartime Navy officer. Take a trip down memory lane at the Museum of Brands (no.43), whose memorabilia-filled Time Tunnel offers a nostalgic look back through 200 years of consumer culture.

Extracurricular activities

Try the London Transport Museum (no.9) for spooky tours of disused tube stations, the V&A (no.39) for inspiring short courses and illuminating workshops, and Tate Modern (no.35) for arty evening events complete with DJ sets and drinks.

Exiting via the gift shop

Surely the best bit of any museum visit is bagging yourself some loot at the end. You can't beat the Design Museum (no.37) for design books and magazines, Young V&A (no.15) for beautiful children's gifts, Wellcome Collection (no.47) for quirky medical-themed paraphernalia and Museum of the Home (no.13) for eco-friendly homeware.

1

HUNTERIAN MUSEUM

Unnerving anatomical archive

A severed foot stricken with elephantiasis and a pickled, pregnant Surinam toad covered in half-hatched toadlets are just two of many specimens at this RCS-housed museum that will make you wish you hadn't bothered with breakfast. Founded to accommodate the collection of 18th-century surgeon and anatomist John Hunter, this gruesome archive recently emerged from a six-year renovation that's seen the removal of some controversial exhibits (most notably the skeleton of a 7'7" grave-robbery victim) and the addition of insightful commentary on the questionable ethics of his procurement, along with interactives and displays exploring Hunter's legacy. A must-see (if you can stomach it).

Royal College of Surgeons of England,
38-43 Lincoln's Inn Fields, WC2A 3PE
Nearest station: Holborn
Free entry
hunterianmuseum.org

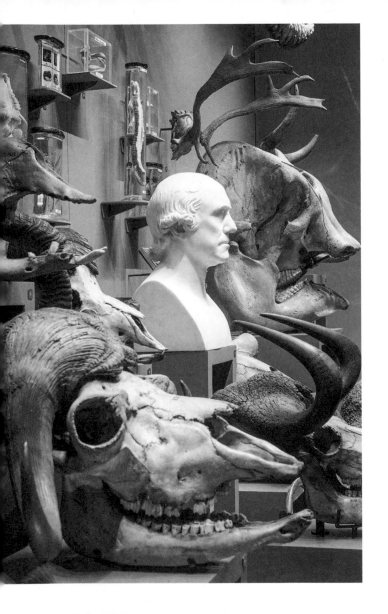

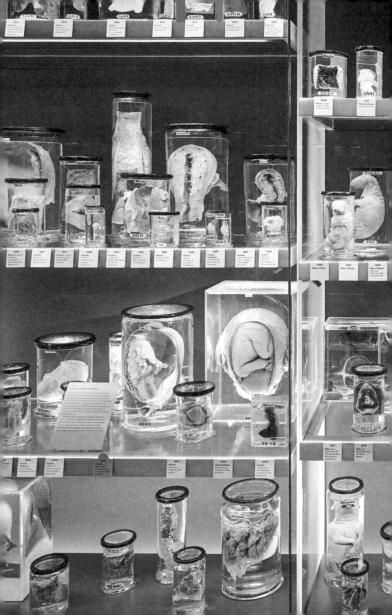

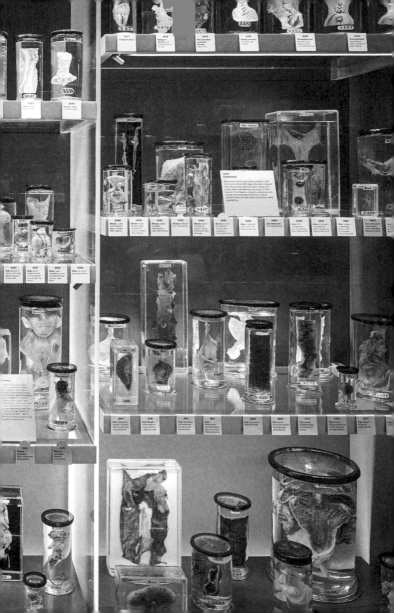

2

NATIONAL GALLERY

Mammoth museum of art

Don't be daunted by the prospect of more than 2,300 paintings (including many of the most famous in the world). While a museum of similar heft elsewhere in Europe would cost a small fortune to visit, the National's free entry means there is no pressure to drag yourself around the whole thing. Overcome with a sudden desire to see Van Gogh's sunflowers, stand before Holbein's *Ambassadors* or glimpse one of Stubbs' striking horses from the other end of the gallery? Nourish your soul with an impromptu lunch break mooch. Of course, there is plenty in the permanent collection to fill a few happy weekend hours, plus an excellent rota of spectacularly curated temporary exhibitions.

Trafalgar Square, WC2N 5DN
Nearest station: Charing Cross
Free entry, some paid exhibitions
nationalgallery.org.uk

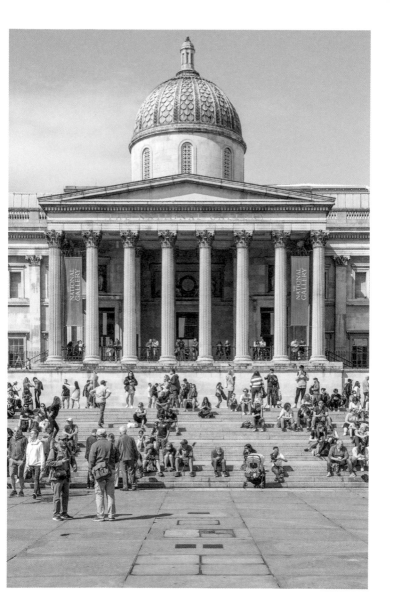

3

PETRIE MUSEUM OF EGYPTIAN ARCHAEOLOGY

Hidden treasures of the ancient world

If the British Museum's eminent Egyptian galleries are already on your itinerary, it would be rude not to also make the five-minute detour to this less famous – but just as significant – historical goldmine. Concealed in a former stable within the UCL complex, this old-school museum maintains more than 80,000 Egyptian and Sudanese artefacts, from hieroglyph-engraved stones to a 4,000-year-old toy pig, plus the gossamer remains of the world's oldest woven garment. Don't leave without reading up on Amelia Edwards, the Egyptologist and donor who preceded Sir Flinders Petrie and after whom the museum should probably have been named instead.

Malet Place, WC1E 6BT
Nearest station: Euston Square
Free entry
ucl.ac.uk/culture/petrie-museum

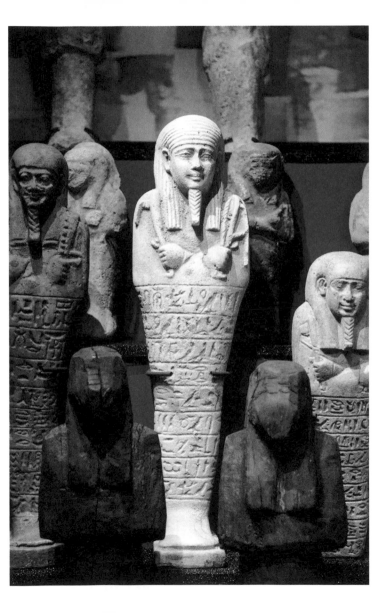

4

BRITISH MUSEUM

Bloomsbury bastion of human history

Contrary to its name, you'll find artefacts hailing from virtually every country on the planet at Britain's largest museum, with many of them acquired during the expansion of the British Empire. But despite such controversial origins (and an ongoing debate around repatriating objects), the museum's hoard never fails to pull in the hordes, making for an overwhelming – and often infuriating – outing if you're underprepared. Get ahead of the crowd and plan before you go, being sure to add the charismatic Lewis chessmen, mesmerising Egyptian mummies and cryptic Rosetta Stone – the tablet that unlocked the secret of Egyptian hieroglyphs – to your itinerary.

Great Russell Street, WC1B 3DG
Nearest station: Tottenham Court Road
Free entry, some paid exhibitions
britishmuseum.org

5

NATIONAL PORTRAIT GALLERY

Fourteen centuries of famous faces

It's not often that a gallery's artworks are selected for the significance of the sitter rather than the artist, but that's the policy at this iconic institution, whose collection of portraits – the largest in the world – includes everyone from Henry VIII to Zaha Hadid. Reopened in 2023 following a three-year, £41-million refurbishment, the shiny new NPG aims to be more accessible than its previous incarnation but remains dedicated to spotlighting those who have made an important contribution to British history and culture – however controversial. The newly refurbished Tudor Galleries, Tracey Emin's female-focused doors and Branwell Brontë's haunting portrait of his novelist sisters are all worth seeing.

St. Martin's Place, WC2H 0HE
Nearest station: Charing Cross
Free entry, some paid exhibitions
npg.org.uk

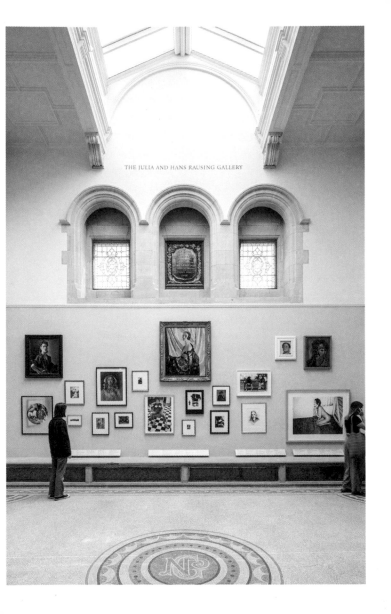

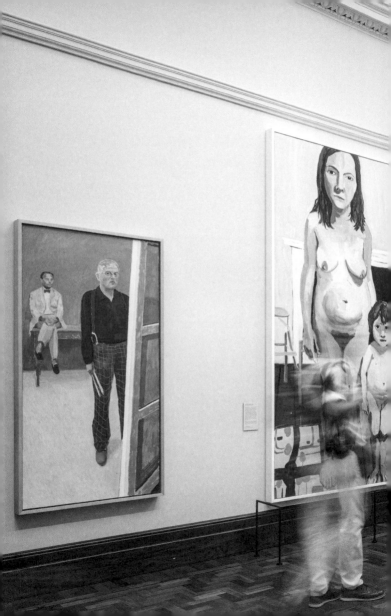

6

CARTOON MUSEUM

Framing the art of humour

Need a good laugh? An underground museum just off Europe's busiest shopping street may not be the most obvious place to find it, but this tongue-in-cheek celebration of cartoons, caricatures and comic strips might just surprise you. Alongside an ever-changing permanent display of cartoons from its 4,000-strong collection, this playful museum hosts an energetic programme of temporary exhibits and workshops guaranteed to put a smile on your face (model making with the creators of *Wallace and Gromit*, anyone?). What's more, it's home to one of the best museum foyers in London – a colourful explosion of oversized comic-book imagery designed to put you in the frame.

63 Wells Street, W1A 3AE
Nearest station: Oxford Circus
Paid entry
cartoonmuseum.org

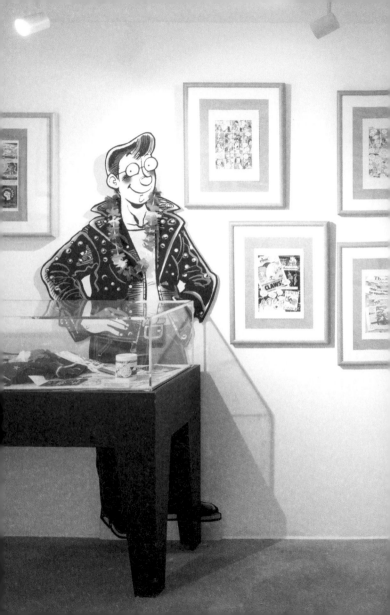

7

SIR JOHN SOANE'S MUSEUM

Idiosyncratic architect's house

Only 90 visitors are permitted access to Sir John Soane's charismatic former home at any one time – which seems like a generous number once you're inside and jostling for space among the 45,000 objects the architect amassed over his lifetime. Kept as it was at the time of his death in 1837, the eccentric Holborn townhouse offers an intimate glimpse into Soane's life and a fascinating insight into Regency London, as well as boasting a collection of art and antiquities to rival the capital's top museums. Time your visit to coincide with the daily unveiling of the original *A Rake's Progress* paintings, Hogarth's still-relevant moral satire.

13 Lincoln's Inn Fields, WC2A 3BP
Nearest station: Holborn
Free entry
soane.org

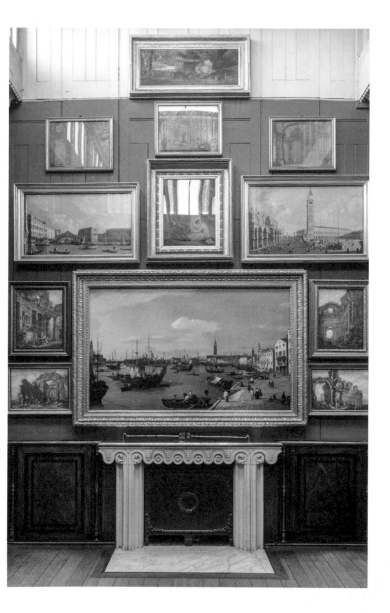

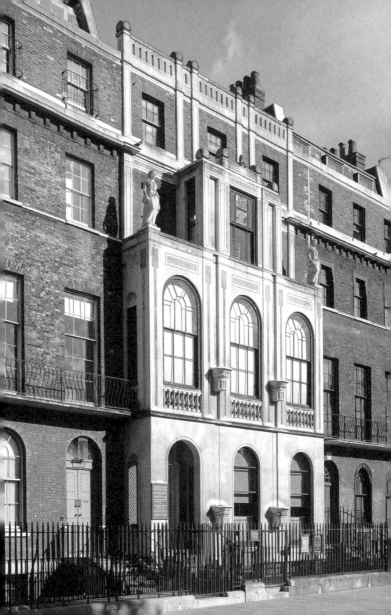

8

POSTAL MUSEUM

Hands-on homage to snail mail

Anyone hoping for wall-to-wall stamp collections will be sorely disappointed by this small but inspiring museum, which communicates the surprisingly compelling history of the British postal service across two neighbouring sites by way of a cleverly designed interactive gallery and captivating miniature Mail Rail ride through 100-year-old subterranean passageways. Opened in 2017, this relative newcomer has fast become a favourite – particularly with young families, who reliably pack out its brilliant Sorted! play space on weekends and under-5s play sessions on weekdays. And yes, you'll find the odd stamp collection here, too.

15-20 Phoenix Place, WC1X 0DA
Nearest station: Farringdon
Paid entry
postalmuseum.org

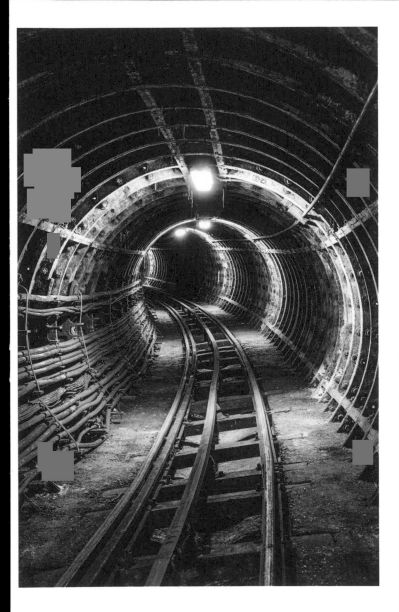

9

LONDON TRANSPORT MUSEUM

Interactive history of transport in the capital

As anyone who's ever lived south of the river will attest, London's transport system isn't always a source of joy. Thankfully that's not the case at this Covent Garden favourite, whose chronologically arranged galleries offer visitors an engrossing romp through the history of transportation in the capital, spanning horse-drawn omnibuses from the 1820s through to the newly launched Elizabeth Line. Plentiful interactives, a TfL-themed play space and the popular stamper trail make weekends a largely family affair, but there's still plenty here to engage grown-up transport buffs, from museum lates to atmospheric tours of long-abandoned stations.

Covent Garden Piazza, WC2E 7BB
Nearest station: Covent Garden
Paid entry
ltmuseum.co.uk

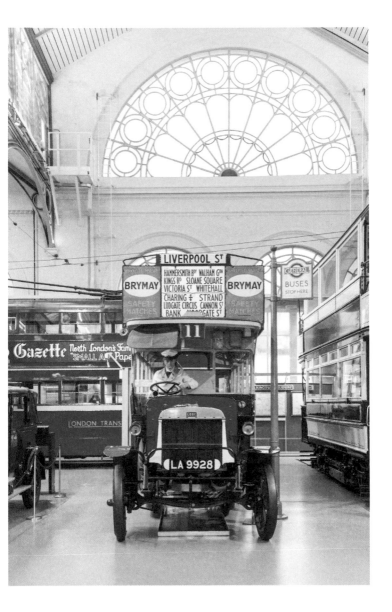

10

FOUNDLING MUSEUM

Heart-breaking history of surrendered children

The story of Britain's first home for abandoned children could be oppressively bleak, but here it is handled with maturity and sensitivity, equal parts devastating and uplifting. Exhibits include reconstructions of rooms from Thomas Coram's now-demolished Foundling Hospital and an affecting introductory gallery chronicling foundlings' stories and displaying their personal possessions – most hauntingly, the tokens left by mothers to help the hospital match them, should they ever return to claim them. As well as being home to a notable permanent art collection, the museum hosts a compelling programme of related exhibitions and, aptly, some of the best creative workshops for children in the capital.

40 Brunswick Square, WC1N 1AZ
Nearest station: Russell Square
Paid entry
foundlingmuseum.org.uk

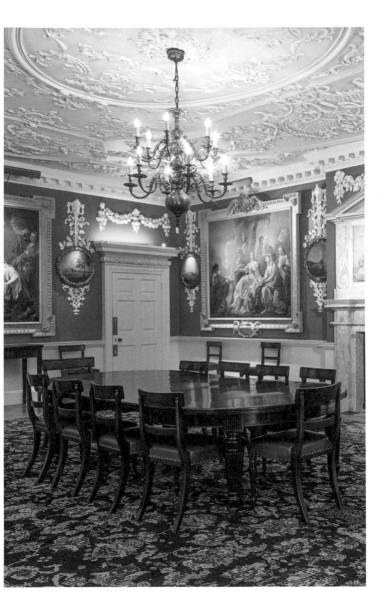

11

CHARLES DICKENS MUSEUM

Atmospheric author's house

Dickens only lived at 48 Doughty Street for two of his 58 years, but there's still a powerful sense that its walls have witnessed great things. The novelist finished three of his most important works here and, despite his having moved out nearly two centuries ago, the interior has been reconstructed as though he just stepped out for a walk – with actor-led tours available should you need a little more convincing. With more than 100,000 artefacts (including original letters and manuscripts) on site, there's always plenty to see here, but it's at Christmas – a tradition that Dickens helped revive – that this evocative museum really comes to life. Check the website for a flurry of festive events – no Scrooges allowed.

48-49 Doughty Street, WC1N 2LX
Nearest station: Russell Square
Paid entry
dickensmuseum.com

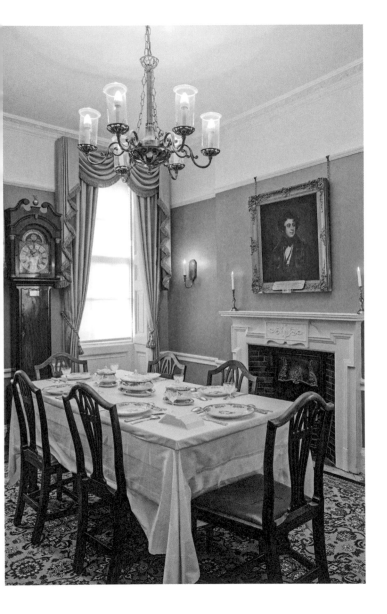

12

TOWER OF LONDON

Medieval castle with grisly history

It's said that if the six resident ravens ever leave this former palace and one-time prison, both the Tower and the kingdom will fall – a claim outlandish enough to warrant a visit all on its own. But there's a lot more to London's oldest intact structure than its flock of winged protectors and the Crown Jewels they guard. Beat the latter's famously lengthy queues by arriving ahead of opening, then embark on a whirlwind tour of the complex, courtesy of one of the entertaining Yeoman Warders who have been stationed here since Tudor times. Come after dark to witness these so-called 'Beefeaters' lock up the Tower as part of the 700-year-old Ceremony of the Keys (booking essential).

Tower of London, EC3N 4AB
Nearest station: Tower Bridge
Paid entry
hrp.org.uk/tower-of-london

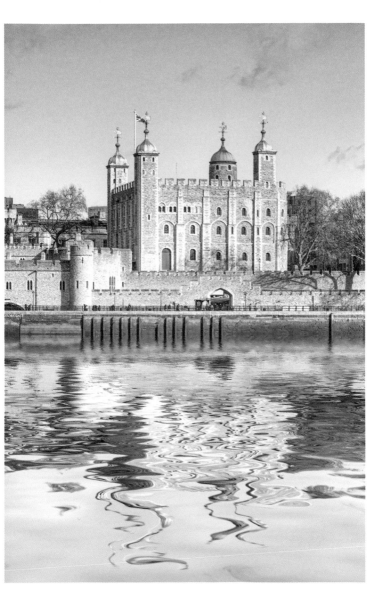

13

MUSEUM OF THE HOME

Thought-provoking window into Londoners' lives

The former Geffrye Museum's name change in 2021 served not only to distance the organisation from the slave trader who financed the alms-houses it inhabits; it signalled a complete refocus of its content following its renovation. Today, the museum paints a comprehensive picture of Londoners at home, with a greater emphasis on present-day residents than its forerunner and better provision for its youngest visitors, with a charming sensory space and role-play area, as well as seemingly endless interactives. Exit via the out-standing gift shop (a treasure trove of beautiful and eco-friendly homeware) and verdant Gardens Through Time – a patchwork recreation of domestic green spaces through the ages.

136 Kingsland Road, E2 8EA
Nearest station: Hoxton
Free entry
museumofthehome.org.uk

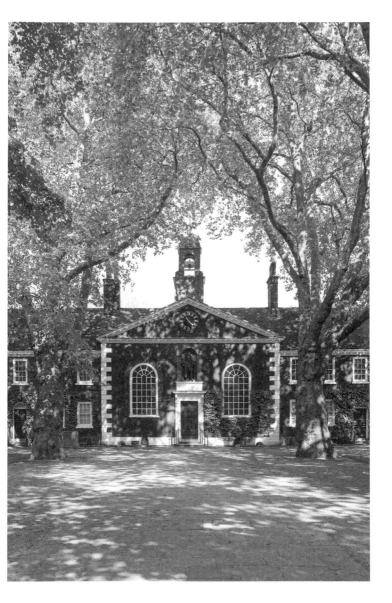

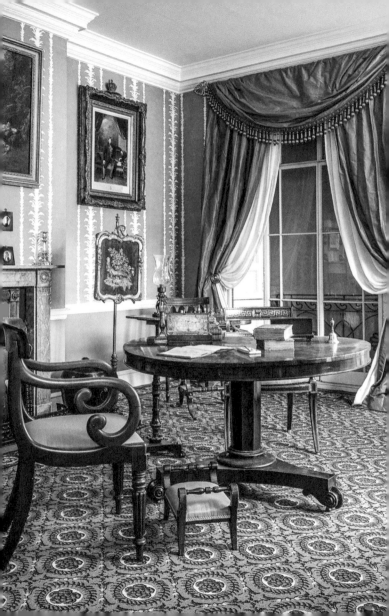

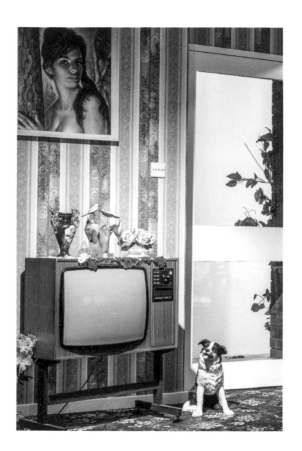

14

WILLIAM MORRIS GALLERY

Socialist designer's childhood home

It's testament to Morris's genius that his designs are instantly recognisable nearly two centuries after their conception. Housed in his family home, this atmospheric gallery is host to the world's largest collection of Morris's work and stages temporary exhibitions of contemporary (but no less radical) works of art, fashion and photography examining our relationship with the natural world. Well-curated displays paint a comprehensive picture of the revolutionary designer and social activist's eventful life, and bountiful interactives should keep the next generation of artists and advocates busy – but be sure to make time for a haggis toastie at resident cafe Deeney's, which overlooks Morris's former garden.

Lloyd Park, Forest Road, E17 4PP
Nearest station: Walthamstow Central
Free entry
wmgallery.org.uk

15

YOUNG V&A

Children's museum with emphasis on play

Dated toddler favourite the V&A Museum of Childhood reopened in 2023 following an expensive revamp and a snazzy name change. Reconceived as a museum *for* childhood (rather than *of* it), the Young V&A is designed to be more inclusive, interactive and contemporary than its predecessor, with a built-in performance space, a design gallery for 11-14s (often occupied by resident artists) and invitations to play wherever you look, whether it's an avenue of dolls' houses or a giant marble run. Granted, the vintage Sindy dolls and 1980s board games are still pride of place in those familiar glass cabinets, but while the museum's prime audience was once nostalgic parents, the spotlight has perceptibly shifted onto their (delighted) kids.

Cambridge Heath Road, E2 9PA
Nearest station: Bethnal Green
Free entry, some paid exhibitions
vam.ac.uk/young

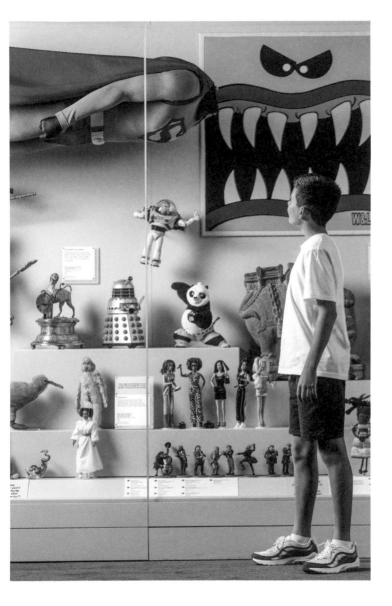

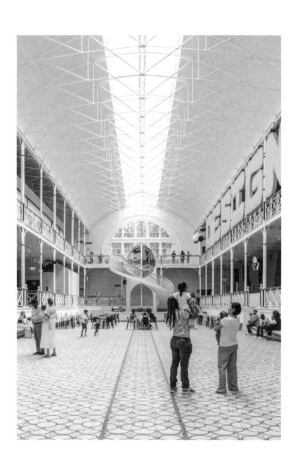

16

VIKTOR WYND MUSEUM OF CURIOSITIES

Perverse paraphernalia in bar basement

'Curiosities' is one way to describe this debauched compendium of objects, which includes (but is no means limited to) a wax model of a syphilitic penis, a jar of used condoms poached from the Rolling Stones' hotel room and a stool sample collected from Kylie Minogue. Whether any of these items are as authentic as Viktor Wynd, this tiny museum's proprietor, would have you believe is debatable – particularly when they're displayed next to a gang of mummified fairies and a fully articulated mermaid skeleton. Still, any creeping doubts shouldn't detract from your enjoyment of this ghoulish spectacle – particularly if it's after a couple of cocktails in the absinthe parlour upstairs.

11 Mare Street, E8 4RP
Nearest station: Cambridge Heath
Paid entry
thelasttuesdaysociety.org

17

VAGINA MUSEUM

Myth-busting celebration of genitals

The fact that its founders opted not to call it the Vulva Museum – despite that being a more accurate description of its remit – because most people don't know what 'vulva' means sums up why the world needs its first museum of gynaecological anatomy. Warm and life-giving (much like a vagina), this exciting new space is home to an airy cafe; community galleries showcasing work from local organisations and people; and empowering ex-hibits on subjects as emotive and overlooked as endometriosis and gynodiversity. Subscribe to the newsletter for updates on the taboo-smashing *Cliterature* book club and *Pub(e) Quiz*, whose prizes (which have previously included a crochet clitoris) all come from the excellent souvenir shop.

275-276 Poyser Street, E2 9RF
Nearest station: Bethnal Green
Free entry
vaginamuseum.co.uk

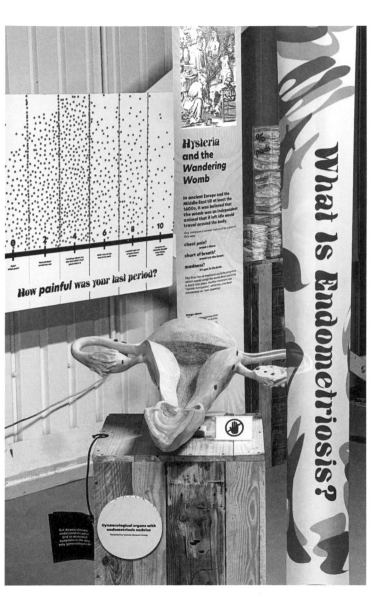

How painful was your last period?

Hysteria and the Wandering Womb

In ancient Europe and the Middle East till at least the 1600s, it was believed that the womb was an independent animal that if left idle would travel around the body.

Any symptom a woman had could be explained this way:

chest pain?

short of breath?

madness?

What Is Endometriosis?

Gynaecological organs with endometriosis nodules

18

MUSEUM OF LONDON DOCKLANDS

Absorbing history of the Thames and docks

If ever there was a reason to ride the glorified rollercoaster that is the DLR, visiting this woefully underrated museum is it. Housed in an atmospheric Georgian sugar warehouse, the museum's collection encompasses a variety of objects dating from the Roman Empire's Londinium through to the docklands' regencration in the 1980s, with much of it displayed in the form of interactive installations that bring the area's rich history to life. Any young ones coming along for the ride will be well catered for here, with hands-on activities throughout and an engaging children's gallery complete with a DLR-themed soft play that's arguably even more fun than the real thing.

No 1, West India Quay, E14 4AL
Nearest station: West India Quay
Free entry, some paid exhibitions
museumoflondon.org.uk

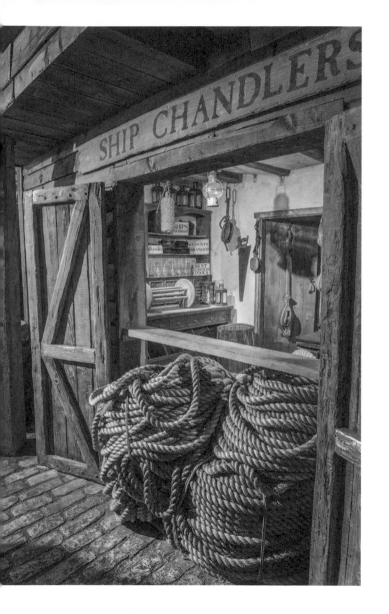

19

DENNIS SEVERS' HOUSE

Candlelit 'time machine' in a Georgian townhouse

Today's state-of-the-art immersive exhibitions don't hold a candle to this spellbinding museum – a convincingly reconstructed (if historically embellished) 'still-life drama' that transports visitors on a hyper-sensorial journey inside an 18th-century terrace. The life's work of eccentric former owner and namesake Dennis Severs, who passed away in 1999, this dreamlike installation has been assembled as though it is still lived in, with everything from half-eaten plates of remarkably realistic food (complete with bite marks) to unmade beds and still-crackling fires, making for an at times uneasy encounter. Whether you opt for the revealing guided or atmospheric silent tour, few museum experiences are as captivating (or smelly).

18 Folgate Street, E1 6BX
Nearest station: Shoreditch High Street
Paid entry
dennissevershouse.co.uk

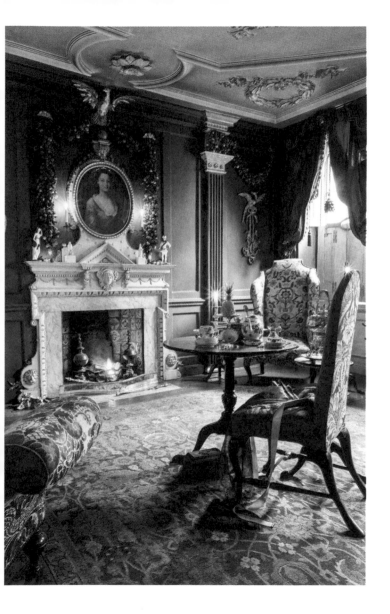

20

IMPERIAL
WAR MUSEUM

First-hand accounts of modern conflict

Think war's a bore? Let a wander through this absorbing museum of conflict combat your ennui. Founded while the First World War raged as a way of documenting events still taking place, IWM covers conflicts from the early 20th century to the present day, with an emphasis on personal experience. Regular guided tours offer in-depth explorations of individual galleries, though most have been curated to cater to families, with a reproduction of a 1940s living room, mocked-up trenches and a healthy smattering of interactives designed to make the trickier topics more palatable. The moving Holocaust galleries are justifiably less child-friendly, but their skilful handling of the atrocities makes a repeat solo visit obligatory.

Lambeth Road, SE1 6HZ
Nearest station: Lambeth North
Free entry, some paid exhibitions
iwm.org.uk

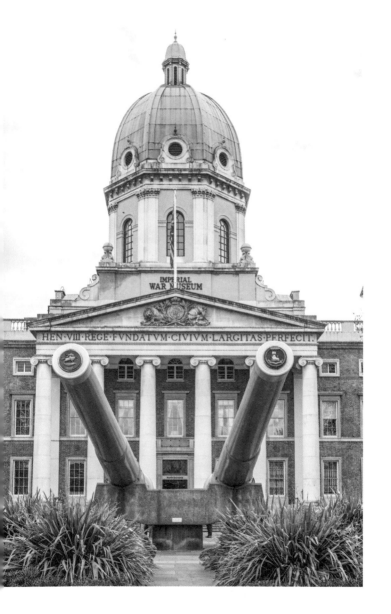

21

NATIONAL MARITIME MUSEUM

Vast museum of nautical endeavours

The world's largest maritime museum makes for an unsurprisingly excellent adventure whatever age the explorer, with more than two million items to discover – including the actual coat Admiral Nelson wore at the Battle of Trafalgar – and plenty of hands-on fun for mini mariners. Set in the glorious surrounds of Greenwich Park, one of London's eight Royal Parks, NMM encompasses 14 spellbinding galleries covering everything from polar exploration to Pacific encounters, as well as two interactive play areas and a spectacular pirate-themed playground helmed by a gigantic kraken. It's too much for a single day, so be prepared to make a return voyage.

Romney Road, SE10 9NF
Nearest station: Cutty Sark
Free entry, some paid exhibitions
rmg.co.uk/national-maritime-museum

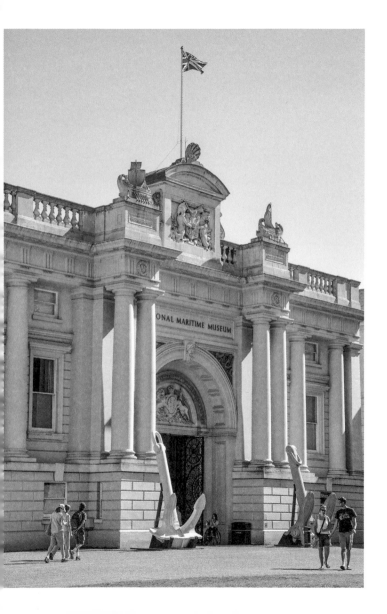

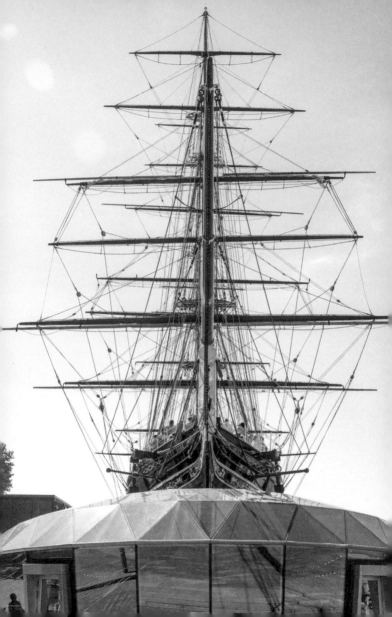

22

HORNIMAN MUSEUM AND GARDENS

Quirky museum with rich natural history collection

Revered as much for its menagerie of taxidermied beasts as its living aquarium, butterfly house and outdoor animal walk, this eccentric spot is a particular favourite with families – as school-holiday visits will affirm. Temporary exhibitions mostly cater to young ones, with past hits including a sea life-themed soft-play space and a hands-on ode to the humble LEGO brick, but the culturally rich permanent galleries will appeal to all. Sunny days call for picnics in the pretty gardens, while wetter ones are a welcome sign to hunker down in the cafe with a coffee and a pile of walrus biscuits – an homage to the museum's comically over-stuffed celebrity centrepiece.

100 London Road, SE23 3PQ
Nearest station: Forest Hill
Free entry, some paid exhibitions
horniman.ac.uk

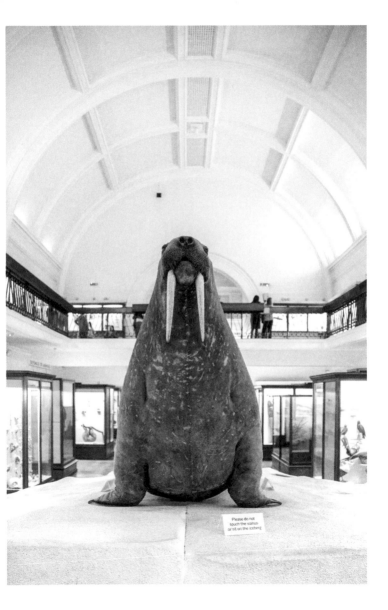

Please do not
touch the walrus
or sit on the iceberg

23

FLORENCE NIGHTINGALE MUSEUM

Experiential tribute to the 'lady with the lamp'

Anyone who's ever so much as had their blood pressure assessed should be obligated to visit this underappreciated museum, which explores the life and legacy of the famed founder of modern nursing. Nestled next to St Thomas' Hospital on the site of Nightingale's nursing school, the museum offers an intriguing insight into the nurse-campaigner's impact on healthcare, as well as hosting well curated, often immersive temporary exhibitions. Point mini medics in the direction of the impressive historical dress-up rail – or, better still, time your visit to coincide with convincing in-character performances from 'Florence' or her oft-overlooked contemporary Mary Seacole.

2 Lambeth Palace Road, SE1 7EW
Nearest station: Westminster
Paid entry
florence-nightingale.co.uk

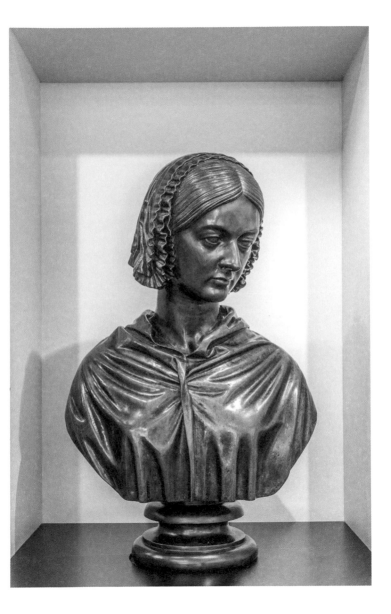

24

OLD OPERATING THEATRE

Museum of surgical history and early medicine

Numerous gory delights await the brave at this nauseating museum, from a grotesque display of rudimentary surgical implements to a chance to play surgeon in the UK's oldest-surviving operating theatre – or at least to grab a friend and a pose for a picture with a rusty saw prop. The space is relatively small and it's anyone's guess how 18th-century amputees descended the treacherously steep spiral staircase, but the clued-up volunteers make a visit here a must (and there's a 20th-century lift for those who need it). Don't leave without having a go at milling your own pills in the apothecary for a little light relief.

9a St Thomas Street, SE1 9RY
Nearest station: London Bridge
Paid entry
oldoperatingtheatre.com

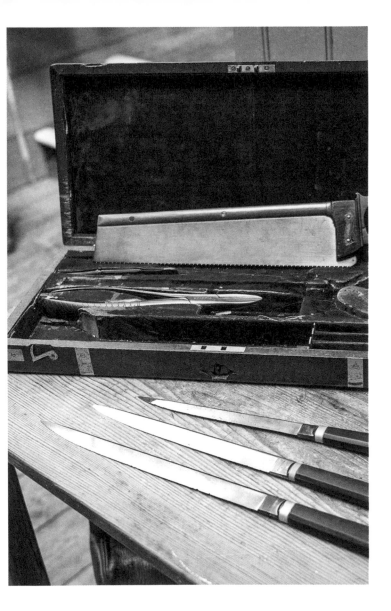

25
THE BRUNEL MUSEUM

Illuminating history of the Thames Tunnel

The Brunel might be small, but the feat of engineering it commemorates is colossal. Today, you'd barely register the one-minute Overground journey from Wapping to Rotherhithe, but when Marc Isambard Brunel's Thames Tunnel opened as the first ever underwater tunnel in 1843, it was hailed as the Eighth Wonder of the World. Open to the public for more than 50 years, the museum houses a modest yet informative display showcasing Brunel's accomplishments and runs tours of the atmospheric Tunnel Shaft – a pleasingly echoey 42ft-deep tower that once hosted the world's first underground party. Time your trip to coincide with the opening of the delightful Midnight Apothecary – a botanical cocktail bar that sporadically pops up on the museum roof.

Railway Avenue, SE16 4LF
Nearest station: Rotherhithe
Paid entry
thebrunelmuseum.com

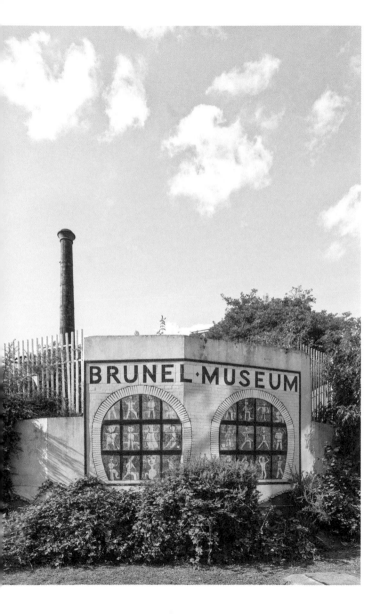

26

HAMPTON COURT PALACE

Majestic abode of Henry VIII

Days out don't get grander than a trip to the residence of the richest (and most infamous) monarch in English history. Often referred to as Henry VIII's pleasure palace, Hampton Court remains a virtually endless source of entertainment today, and whether you're ghost-hunting in the Haunted Gallery, discovering masterpieces in the Cumberland Art Gallery or marvelling at the vastness of the king's kitchens, few historic houses succeed in bringing the past so spectacularly to life. Kids are particularly well served here, with ice skating in the winter months and an epic myths-and-legends-themed playground in the summer – not forgetting the UK's oldest surviving (and perhaps most devilish) hedge maze.

Hampton Court Way, East Molesey, KT8 9AU
Nearest station: Hampton Court
Paid entry
hrp.org.uk/hampton-court-palace

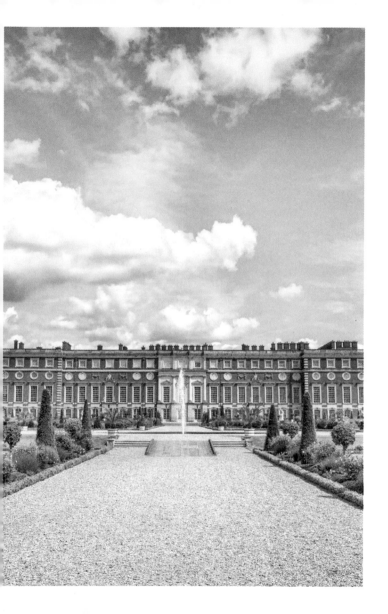

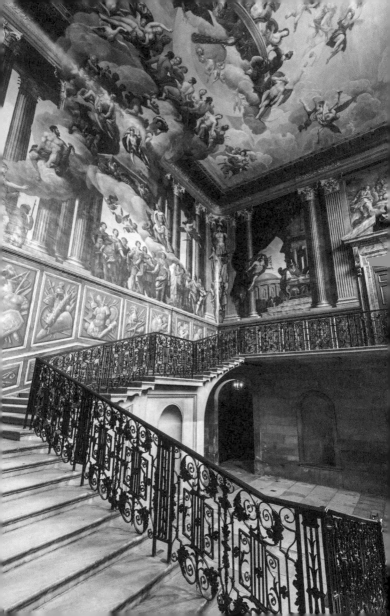

27

HMS BELFAST

Historic warship museum

It's almost stiflingly easy to imagine life aboard this former WWII warship, whose labyrinthine interior has remained largely unchanged since the 1950s – even if the band of merry mannequins that until recently helped to bring its colourful history to life have been retired. In their place, digital displays, compelling audio and even an interactive gaming room all simulate the naval experience, but it's simply in roaming the decks – ladders and all – that this rambling time warp really comes alive. And while the waxworks might be gone, the Belfast's motley crew of knowledgeable volunteers will ensure your naval know-how is watertight.

The Queen's Walk, SE1 2JH
Nearest station: London Bridge
Paid entry
iwm.org.uk/visits/hms-belfast

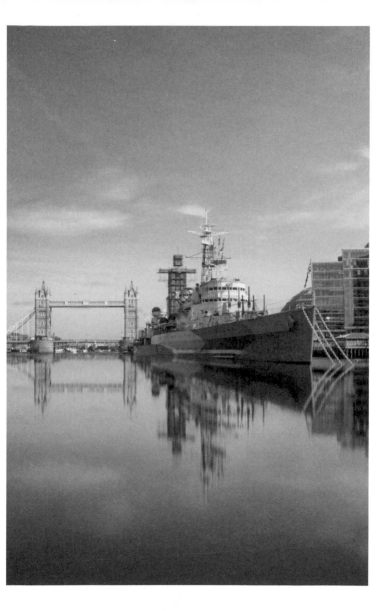

28

WIMBLEDON LAWN TENNIS MUSEUM

Comprehensive history of oldest tennis tournament

The Championships at Wimbledon may only run for a fortnight, but grass-court connoisseurs can get their fix year-round courtesy of this *(ahem)* ace museum. Tracing the history of lawn tennis from its Victorian origins through to modern-day innovations, this subterranean showcase is almost as engrossing as a Federer-Nadal showdown, with interactive highlights including a TV that lets you tune in to significant matches throughout history, a chance to lift mock-ups of the famous trophies and a *Where's Wally*-style Andy Murray search game against the clock. Combine with the award-winning guided tour of the grounds for a chance to pound Murray Mound without the need to beat the (hugely oversubscribed) ballot.

3 Church Road, SW19 5AG
Nearest station: Southfields
Paid entry
wimbledon.com

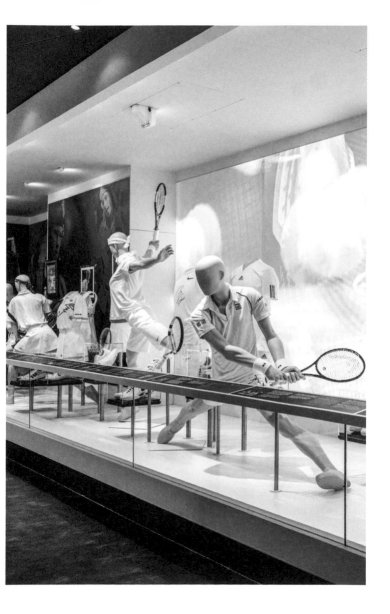

29

FASHION AND TEXTILE MUSEUM

Inspiring showcase for garment design

This thought-provoking museum's highlighter-bright facade will come as no surprise to anyone familiar with the work of its founder, the iconic pink-haired designer Zandra Rhodes. Now owned by Newham College, its diverse programme of exhibitions never ceases to amaze even the most dedicated followers of fashion, with past hits including an Orla Kiely retrospective featuring giant dresses suspended from the ceiling and a blindingly colourful celebration of Californian textile legend Kaffe Fassett's vibrant career. There's no permanent display but that feels apt for a museum dedicated to an industry that never stands still – and makes at least biannual visits a must.

83 Bermondsey Street, SE1 3XF
Nearest station: Westminster
Paid entry
fashiontextilemuseum.org

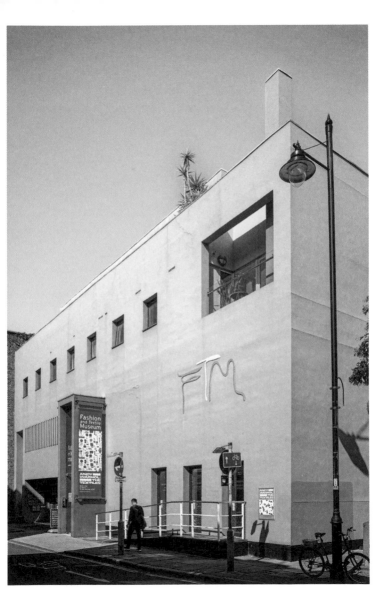

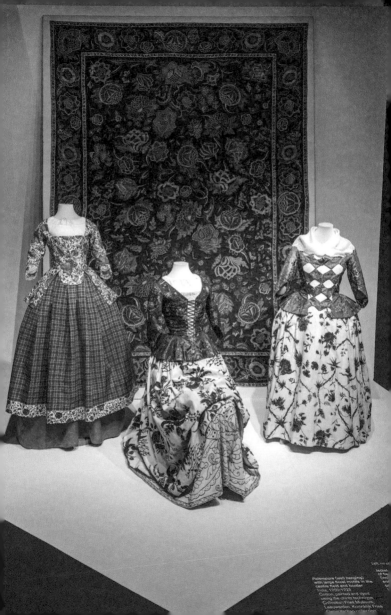

30

MIGRATION MUSEUM

Exploration of movement to and from the UK

When you consider that 40 per cent of Londoners are born outside the UK, it's outrageous that this museum didn't exist until 2013 – and even then, it only ran as a pop-up for the first four years of its life. It's more than made up for lost time, and today offers a remarkably inspiring, if under-sung, platform for discussions around migration and identity. It may be housed in a rather drab shopping centre (though with plans to move to a state-of-the-art permanent home in Aldgate in the next few years), but this unlikely setting is home to moving immersive exhibitions, engaging personal storytelling and a brilliant 'Makers Market' shop championing migrant-owned businesses.

Lewisham Shopping Centre, SE13 7HB
Nearest station: Lewisham
Free entry
migrationmuseum.org

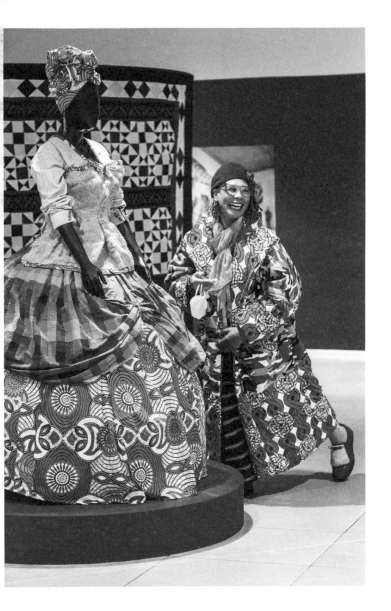

31

HOUSE OF DREAMS

Eccentric artist's house

Ever fancied having a poke around in someone else's head? A tour of Stephen Wright's East Dulwich semi is possibly the closest you'll get. Twenty-five years in the making (and counting), the property's ground floor and garden take the form of a giant immersive art installation: a monument to the artist's loves and losses consisting of thousands of tenderly amassed curios, each one very deliberately placed. From broken baby dolls to sculptures assembled from the possessions of long-gone loved ones, the result is at once moving and unsettling. The museum is open to view roughly once a month during 90-minute tours hosted by Stephen and his partner (who are both available for hugs should it all get a bit much).

45 Melbourne Grove, SE22 8RG
Nearest station: East Dulwich
Paid entry
stephenwrightartist.com

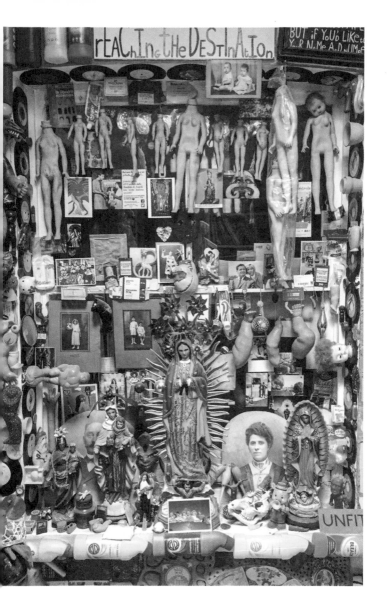

32

ELTHAM PALACE
AND GARDENS

Tudors, millionaires and ring-tailed lemurs

Its medieval great hall, once frequented by a young Henry VIII, is reason enough add this little-known gem to your bucket list, but the breathtaking Art Deco extension should bump it straight to the top. Latterly the home of eccentric – though exceptionally tasteful – millionaires Stephen and Virginia Courtauld, Eltham Palace has been exquisitely restored to its 1930s glory, making a mosey through its lavish accommodation a must for design devotees – or anyone who likes their stately homes with an edge. Kids will go wild for tales of the Courtaulds' pet lemur – not to mention the themed playground inspired by their exotic travels.

Court Yard, SE9 5QE
Nearest station: Eltham
Paid entry
english-heritage.org.uk

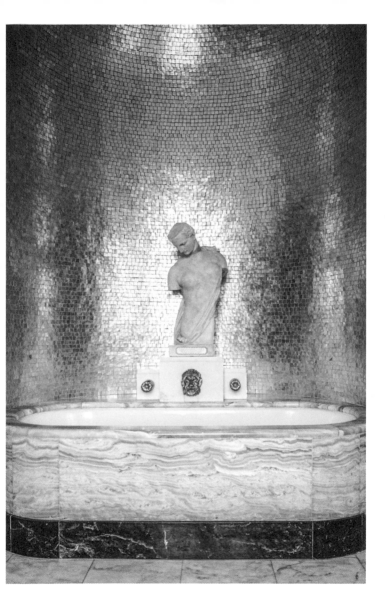

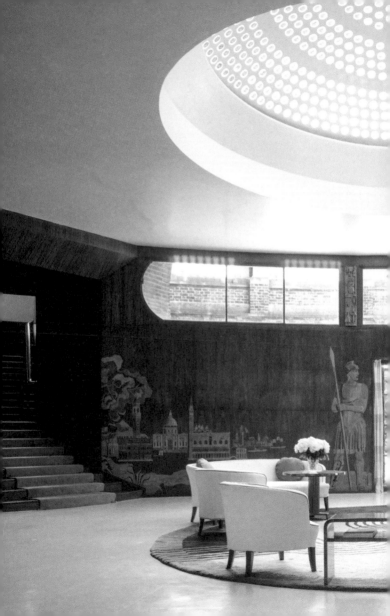

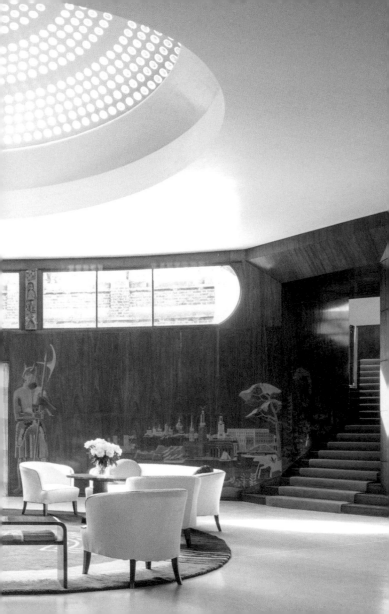

33

GARDEN MUSEUM

Charming tribute to British gardens

A deconsecrated church on a busy Lambeth round-about might strike you as an odd place to open a museum dedicated to gardens, but this exploration of the back yard works rather well. Founded half a century ago following the discovery of 17th-century royal gardener and plant hunter John Tradescant's tomb in the churchyard, the museum pays homage to British gardens and their depictions through history via a lively programme of temporary exhibitions and a permanent display of eccentric paraphernalia. The family offer has vastly improved in recent years and now boasts plenty to keep little green fingers busy, though those with very young ones might want to give the upmarket – albeit lovely – cafe a swerve.

5 Lambeth Palace Road, SE1 7LB
Nearest station: Lambeth North
Paid entry
gardenmuseum.org.uk

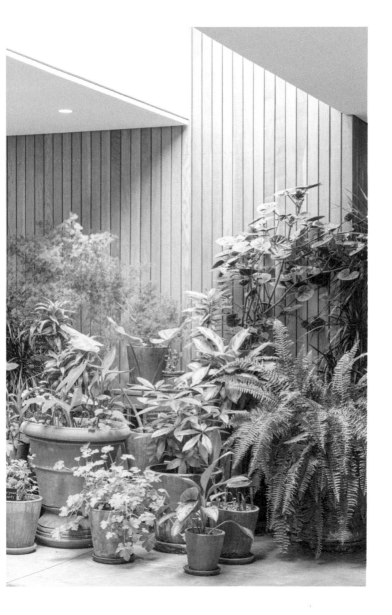

34
DORICH
HOUSE MUSEUM

Sculptor's distinctive Art Deco home

Whether or not you're familiar with Dora Gordine, the Estonian sculptor known for her expressive portrait works, a poke around her striking 1930s studio-home is a must for fans of Modernist design. Built to her specifications – Dorich is a portmanteau of Gordine's first name and that of her husband, the diplomat and scholar Richard Hare – the three-storey house is a bewitching reflection of the charismatic artist, filled with her captivating artworks and even resembling a face at certain angles, with its half-moon window 'eyes'. End your visit on a high with cake in the second-floor tearoom and some fresh air on the vertiginous roof terrace, which overlooks Richmond Park.

67 Kingston Vale, SW15 3RN
Nearest station: Norbiton
Free entry
dorichhousemuseum.org.uk

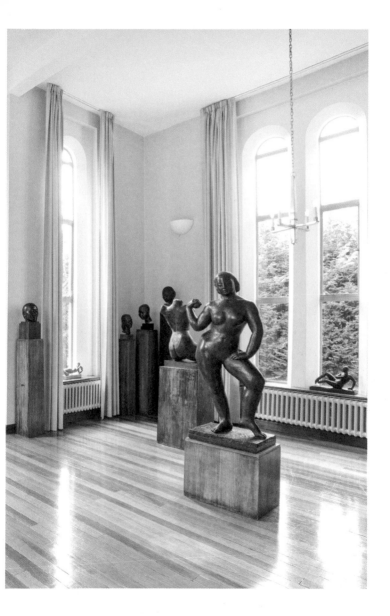

35
TATE MODERN

Colossus of contemporary art

Despite only opening after the turn of the millennium, it's hard to imagine a London without this vast Brutalist cathedral of contemporary art, a former power station that's exhibited such spectacles as Olafur Eliasson's *The Weather Project* and Carsten Höller's *Test Site*, along with innumerable retrospectives, over its relatively short lifespan. Such a rich smorgasbord of transitory treats makes Tate membership well worth splashing out on, but the free-to-view permanent collection is just as exciting, with modern masterpieces spanning Picasso's hypnotic *Nude Woman with a Necklace* and Marcel Duchamp's infamous *Fountain*. Don't miss Tate Lates – an electrifying programme of arty events after dark.

Bankside, SE1 9TG
Nearest station: Blackfriars
Free entry, some paid exhibitions
tate.org.uk

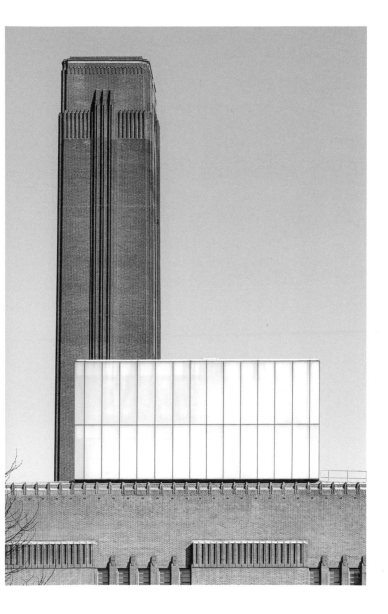

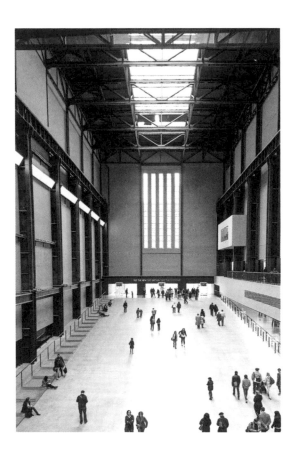

36

BETHLEM MUSEUM OF THE MIND

Harrowing history of infamous psychiatric hospital

The personal accounts of patients admitted to the notorious 'Bedlam' can be bitter pills to swallow, but there's something cathartic about this small museum. Housed within the hospital's current Beckenham site, it aims to promote an understanding of mental illness with its engaging, if disturbing, displays. From the grotesque *Raving* and *Melancholy* statues that once flanked the gates to fragments of a real padded cell and numerous patient photographs, the museum's contents offer a grim but critical window into the murky history of mental health treatment. Don't miss the adjoining art gallery, a platform for artists who have experienced mental health services, that points to a much brighter future.

Bethlem Royal Hospital,
Monks Orchard Road, BR3 3BX
Nearest station: Eden Park
Free entry
museumofthemind.org.uk

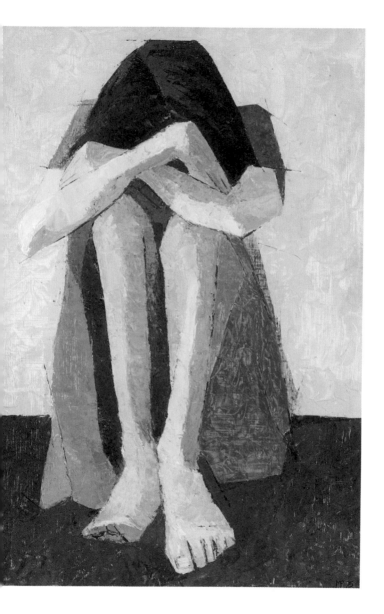

37

DESIGN MUSEUM

Palace of creativity and innovation

You don't need to be the next Conran or Quant to make the pilgrimage to this Modernist Kensington favourite, which celebrates contemporary design from the everyday to the extraordinary. The free-to-enter permanent collection offers a practical introduction to invention for design noobs, featuring almost 1,000 items of 20th- and 21st-century design, from road signs to Anglepoise lamps, each approached from the different perspectives of designer, maker and user. Sign up to the mailing list for news of the diverse programme of workshops and exhibitions spanning saris to skateboards and be sure to save time (and money) for a browse in the excellent shop.

224-238 Kensington High Street, w8 6AG
Nearest station: High Street Kensington
Free entry, some paid exhibitions
designmuseum.org

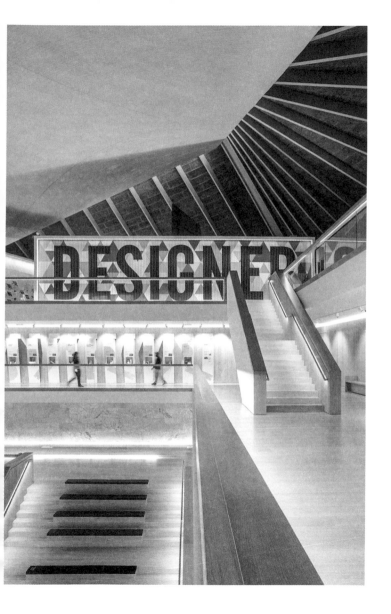

38

NATURAL HISTORY MUSEUM

Dinosaurs, dodos and silent discos

London's most-visited attraction might be famed for its fossils, but there's much more to this life-science Goliath than a load of old bones. Opened in 1881, its spectacular Victorian neo-Gothic building houses artefacts spanning more than 4.5 billion years of history, and yet it still manages to feel current, with cutting-edge temporary exhibitions that bring the past spectacularly to life and sell-out silent discos and sleepovers beneath the iconic blue whale. There's too much to see in one day, but a journey through the centre of the Earth sculpture, a bumpy ride on the earthquake simulator and an intrepid encounter with the animatronic T-Rex are all good starting points for those with kids in tow.

Cromwell Road, SW7 5BD
Nearest station: South Kensington
Free entry, some paid exhibitions
nhm.ac.uk

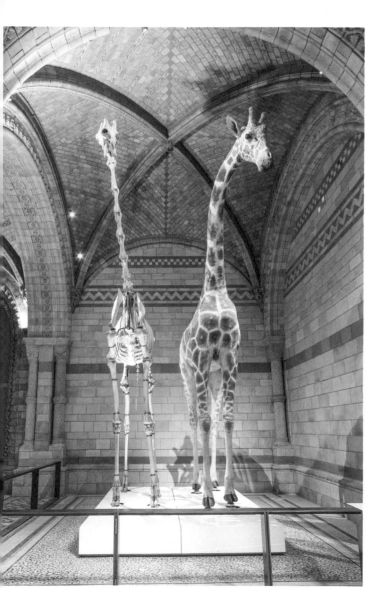

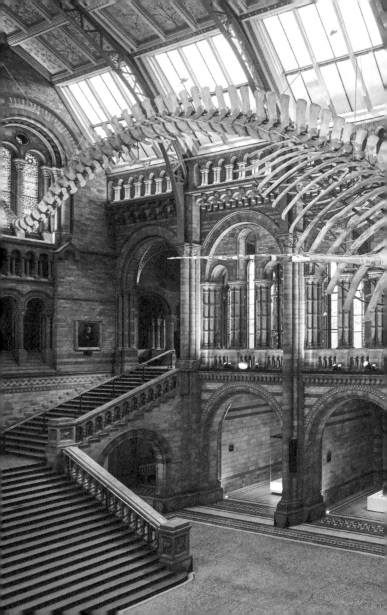

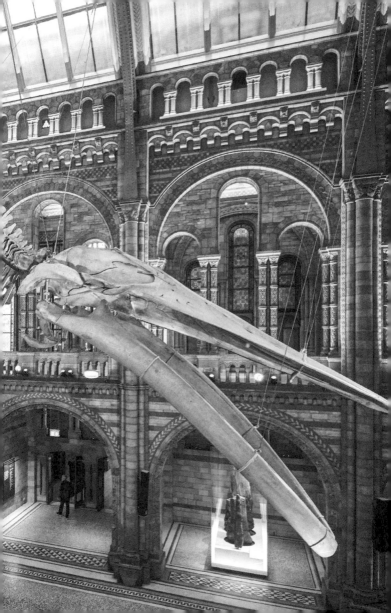

39

VICTORIA & ALBERT MUSEUM

Inspiring giant of art and design

With over 2.8 million objects displayed across 12.5 acres of gallery space, this South Kensington heavyweight is so stuffed with culture it's nigh on impossible to see it all, but that doesn't mean you shouldn't try. The temporary exhibitions tend to steal the spotlight, with erstwhile blockbusters showcasing the work of Alexander McQueen, Tim Walker and David Bowie, but the permanent collection warrants just as much attention, whether you're decrypting Raphael's cartoons or swooning over crinolines in the iconic fashion gallery. Refuel with a slap-up cream tea in the museum's opulent Gamble Room – the world's oldest museum restaurant – then go and see some more.

Cromwell Road, SW7 2RL
Nearest station: South Kensington
Free entry, some paid exhibitions
vam.ac.uk

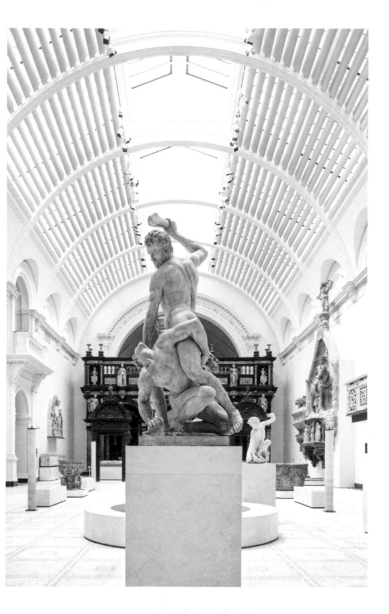

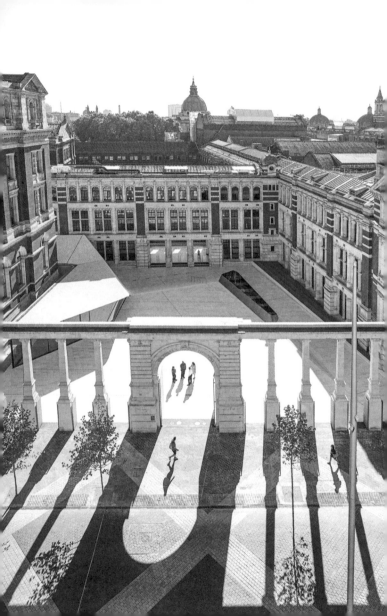

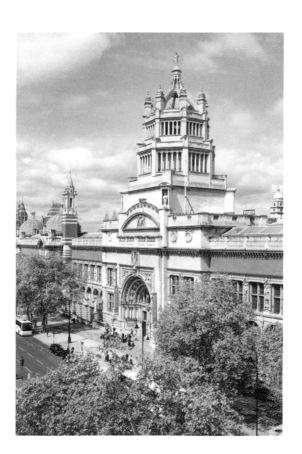

40

TATE BRITAIN

Stately centre for British art

A crash course in the last 500 years of British art awaits you at this palatial gallery, whose collection spans everything from Van Dyck's court paintings to Bridget Riley's Op Art via Turner skyscapes. As well as running a grown-up programme of big-name shows, after-hours Lates and artist-led courses, the Tate Britain is easily one of the most child-friendly galleries in the capital, boasting two creative play spaces, a digital drawing studio and a regular line-up of workshops with inspiring children's authors. Don't miss the annual Duveen Galleries commission, whose past spectacles have included Hew Locke's procession of 100 life-size human sculptures and Anthea Hamilton's anthropomorphic *The Squash*.

Millbank, SW1P 4RG
Nearest station: Pimlico
Free entry, some paid exhibitions
tate.org.uk/visit/tate-britain

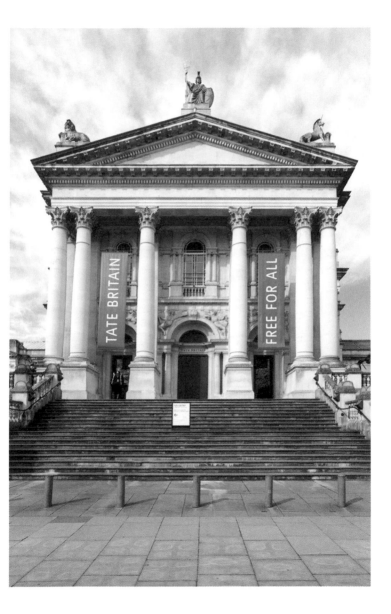

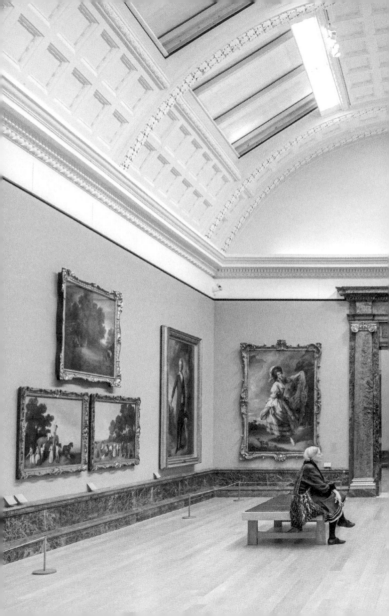

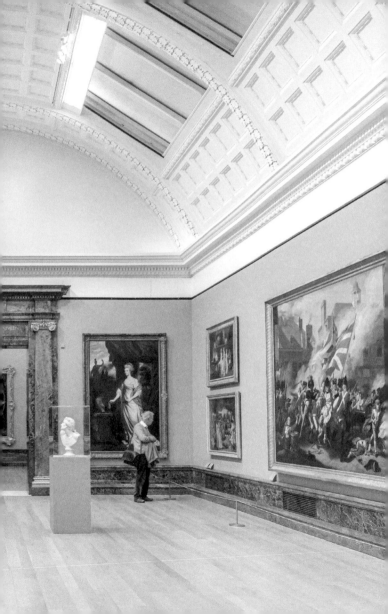

41

ROYAL ACADEMY OF ARTS

Historic art society hosting big-name shows

Its portentous name and well-heeled patrons might make this 250-year-old institution seem a little intimidating, but look beyond its characteristically Mayfair standoffishness and you'll be compensated with some of the most exciting art shows in the capital. As well as blockbuster retrospectives celebrating the careers of artists such as Antony Gormley and Marina Abramović, the RA is famed for its long-running Summer Exhibition – an eclectic mix of emerging and established talent displayed over 3,000 square metres – and rather less well known for its Young Artists' Summer Show, an astounding showcase of kids' creations that offers tremendous promise for the future of art in the UK.

Burlington House, W1J 0BD
Nearest station: Green Park
Free entry, some paid exhibitions
royalacademy.org.uk

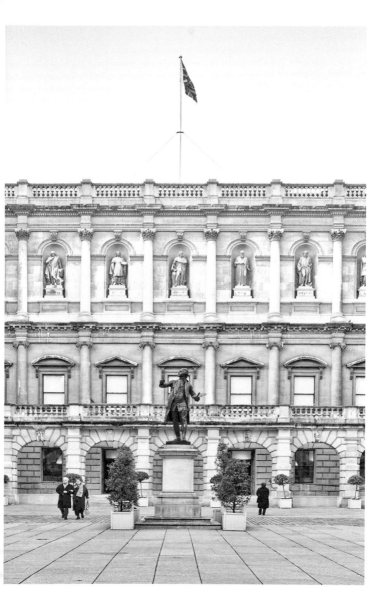

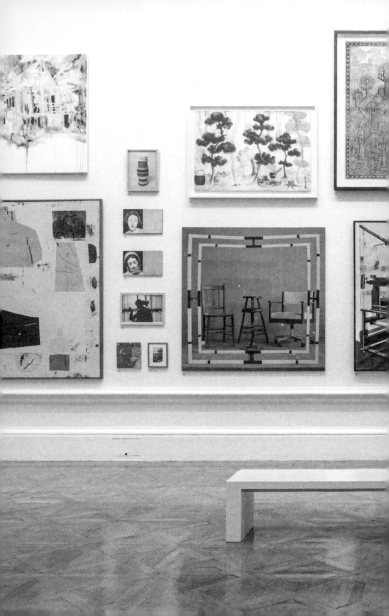

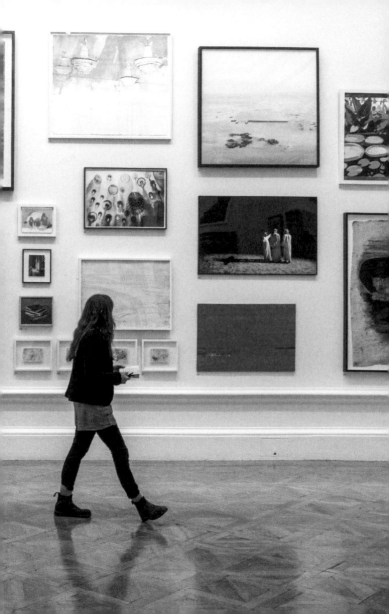

42

WALLACE COLLECTION

European masterpieces in an 18th-century mansion

There's more than a touch of the Versailles about this elegant museum, the former private residence of British aristocrats whose collection of French 18th-century decorative arts is considered the most important outside of France. Along with an unsurpassed array of armour and arms, as well as a substantial hoard of furniture made for Marie Antoinette herself, this somewhat underrated museum is also home to an impressive number of Old Masters – not to mention the calamine-walled, glass-roofed courtyard restaurant whose (naturally) French-inspired menu and lavish afternoon teas are truly fit for a queen.

Hertford House, Manchester Square, W1U 3BN
Nearest station: Bond Street
Free entry, some paid exhibitions
wallacecollection.org

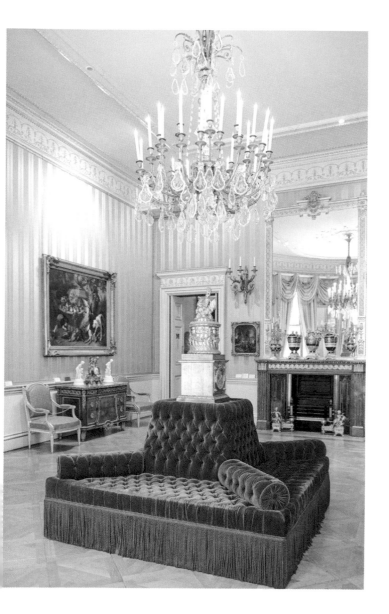

43

MUSEUM OF BRANDS

Two centuries of social history

If it's the bittersweet pang of nostalgia you crave, make a beeline for this Notting Hill treasure trove, whose 12,000 original items of brand packaging and advertising will whisk you on a whirlwind tour through 200 years of consumer culture. At the heart of the museum, the chronologically arranged Time Tunnel offers a literal trip down memory lane, presenting everything from Victorian billboards lauding the benefits of rolled ox tongues to tins of Heinz and tubes of Colgate. If you find the experience surprisingly emotional, you're not alone. The cafe's courtyard garden offers the perfect spot to recover and refuel before picking up a retro memento or two from the superb gift shop.

111-117 Lancaster Road, W11 1QT
Nearest station: Ladbroke Grove
Free entry, some paid exhibitions
museumofbrands.com

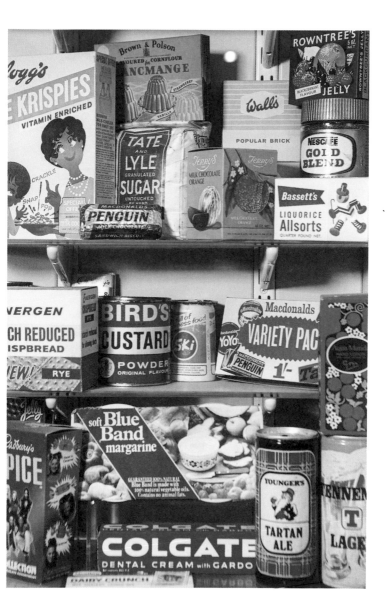

44

SCIENCE MUSEUM

Vast showcase of human ingenuity

A keen interest in science isn't a precondition for a rewarding trip to this hands-on museum, which brings natural phenomena to life via numerous stimulating displays. Laid out across two hangar-like buildings, this family favourite covers everything from space travel to the psyche and energy to IT, with a focus on interactivity that will engross even those firmly in the 'science is boring' camp. Try Engineer Your Future for career-confused teens, the electrifying Wonderlab for practical learning with older kids or the subterranean Garden for themed sensory play with your littlest boffins.

Exhibition Road, SW7 2DD
Nearest station: South Kensington
Free entry, some paid exhibitions
sciencemuseum.org.uk

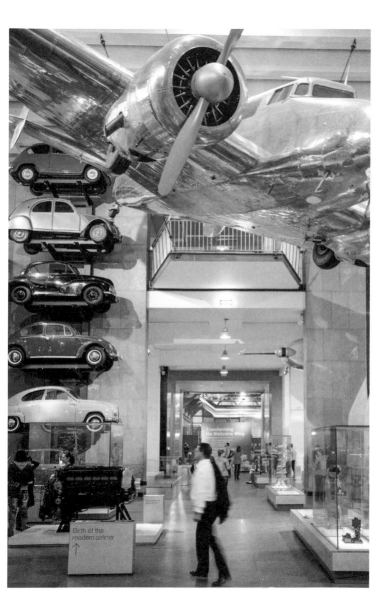

45

LEIGHTON HOUSE

Victorian painter's opulent studio-home

The fact that the music video for Spandau Ballet's 'Gold' was filmed at this impressive museum should be testament enough to its splendour – although you'd expect nothing less of the former home of Frederic Leighton, the celebrated Victorian painter and one-time RA and RIBA president. Built to Leighton's exacting specifications, this palatial townhouse groans with treasures, from his art-stuffed studio to the Iznik-tiled pseudo-Islamic hallway and sumptuous Silk Room. An £8m restoration of the property in 2022 imparted even more pizzazz, with the addition of a superb cafe, contemporary commissions and rediscovered rooms elevating it from hidden gem to the almost other-worldly jewel in Holland Park's crown.

12 Holland Park Road, W14 8LZ
Nearest station: Kensington Olympia
Paid entry
rbkc.gov.uk/museums

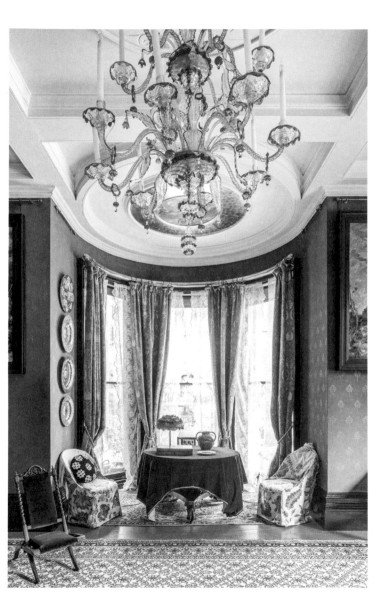

46

KENWOOD HOUSE

Stately home with impressive art stash

Whether it's your first or your 50th visit, it's impossible not to be awestruck by this neoclassical mansion as it emerges like a pearl from Hampstead Heath's dense woodland. Once the residence of the Earls of Mansfield, the former stately home boasts one of the finest art collections you'll find outside a national gallery (including the likes of Vermeer, Rembrandt and Turner), courtesy of its final private owner, philanthropist and prolific art collector Edward Guinness. Weekends in NW3 feel decidedly incomplete without a mooch around the Robert Adam-designed library, bookended by a lengthy Heath walk and a lazy lunch in one of Hampstead's historic taverns.

Hampstead Lane, NW3 7JR
Nearest station: Hampstead Heath
Free entry
english-heritage.org.uk/visit/places/kenwood

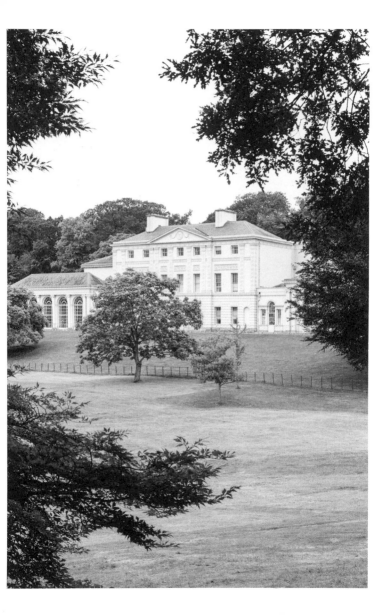

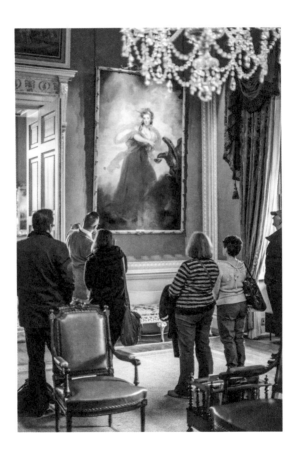

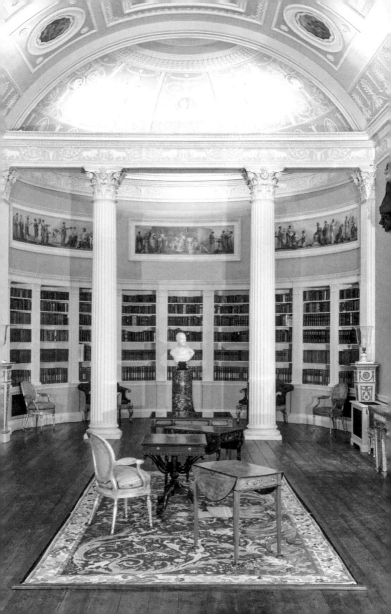

47

WELLCOME COLLECTION

Absorbing exhibits on the human experience

The perpetual gridlock of Euston Road makes it easy to overlook this gem of a museum, whose focus on the intersection of art and medicine has resulted in many compelling and often relatable exhibitions since it opened in 2007, with topics as diverse as mental illness, the science of play and our relationship with milk. Exhibitions are free and everything except the cutting-edge Being Human display is temporary, meaning there's always something new to see – and the restful Reading Room, well-stocked library and exquisitely curated gift shop are all equally excellent reasons to drop in.

183 Euston Road, NW1 2BE
Nearest station: Euston Square
Free entry
wellcomecollection.org

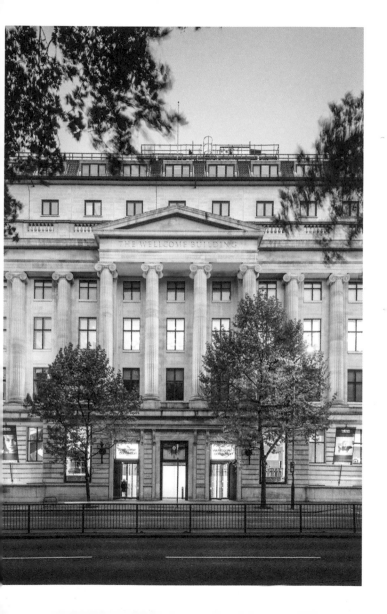

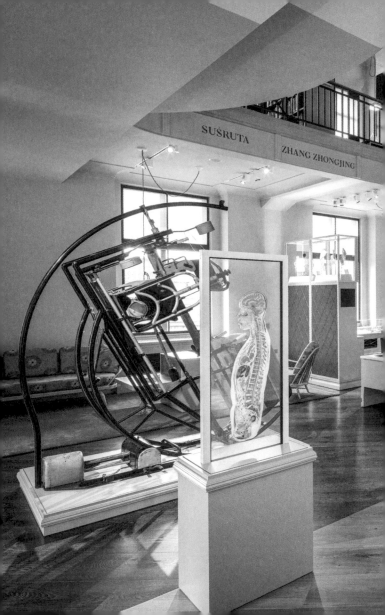

SUŚRUTA

ZHANG ZHONGJING

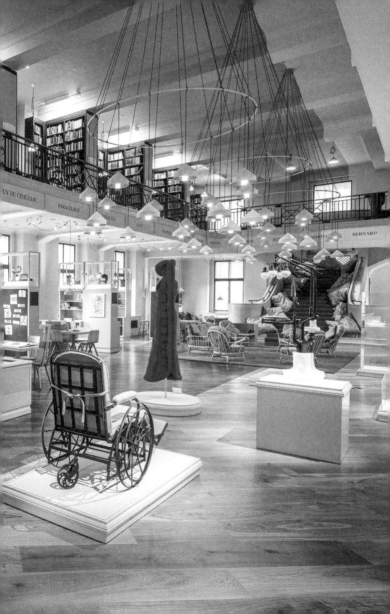

48

KEATS HOUSE

Hampstead gem that inspired Romantic poet

John Keats' tenancy at Wentworth Place (as it was once known) was brief but eventful. The poet met the love of his life while living in one of what was once two houses (she lived in the other), while the restful garden – a well-kept local secret that's free to use during opening hours – is said to be where he composed 'Ode to a Nightingale', under a long-gone (but since-replaced) plum tree. Excellent interior reconstructions and a well-made short film on Keats' short life make for a moving visit to this elegant Regency villa – and one that can be enriched even further by signing up for news of the museum's popular talks, as well as walking tours that explore his most beloved Hampstead haunts.

10 Keats Grove, NW3 2RR
Nearest station: Hampstead Heath
Paid entry
cityoflondon.gov.uk

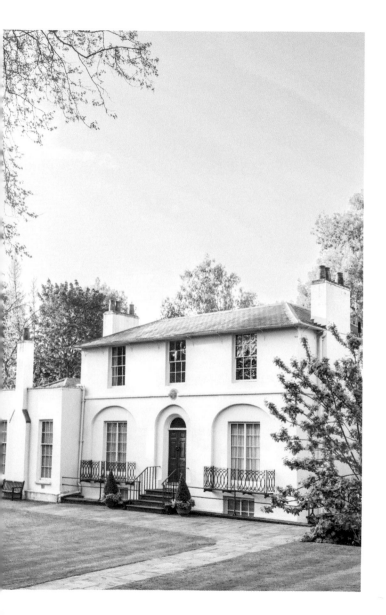

49

FREUD MUSEUM LONDON

Final home of the father of psychoanalysis

Like a museum within a museum, Sigmund Freud's London home is a densely stuffed Aladdin's cave of priceless antiquities, amassed over the course of his remarkable working life. From Neolithic tools to Pompeiian penis amulets, Freud's eclectic hoard adds an extra layer of intrigue to the charismatic abode where both he and his psychoanalyst daughter Anna lived, worked and died – while his legendary therapy couch and seemingly momentarily discarded mouth prosthesis heighten the sense that he's still knocking around. Tune into the lively audio guide, featuring stories from the son of one of Anna Freud's former staff members, to get the most from your visit.

20 Maresfield Gardens, NW3 5SX
Nearest station: Finchley Road
Paid entry
freud.org.uk

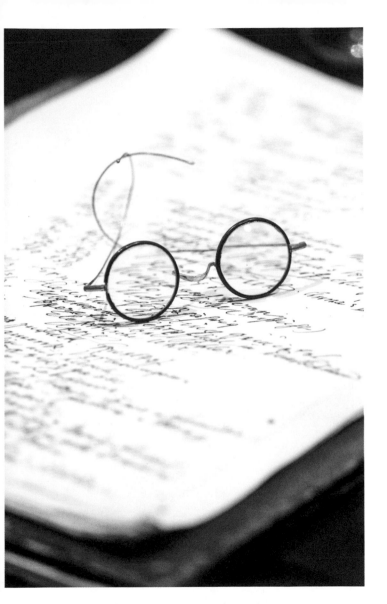

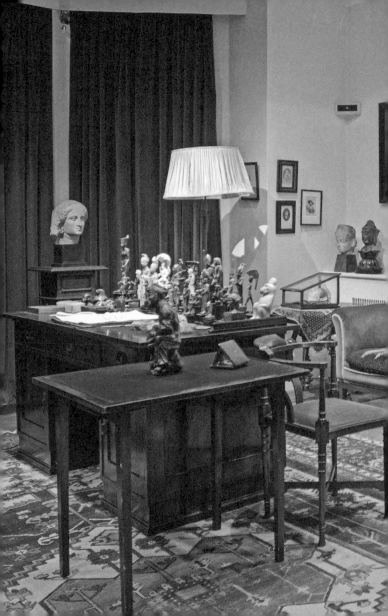

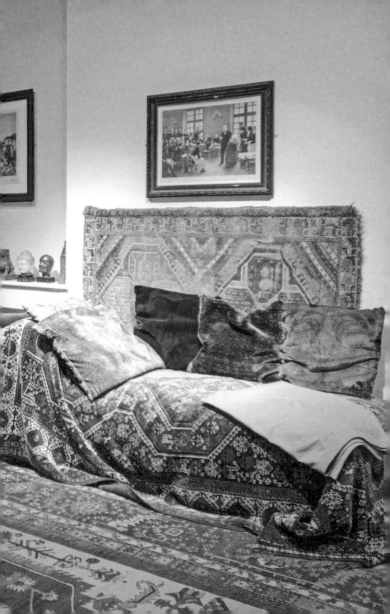

50

QUEER BRITAIN

Riotous celebration of LGBTQ+ life

Three small galleries might seem a woeful allocation for Britain's first and only LGBTQ+ museum, but what it lacks in footprint it more than makes up for in attitude. Founded by former *Gay Times* editor Joseph Galliano to coincide with the 50th anniversary of the UK's first Pride March, Queer Britain is a powerful cacophony of objects and images from over a century of LGBTQ+ life that should be compulsory viewing, whatever your inclination. Keep a (queer) eye on the events programme, which spans everything from protest poster making to collaging for mental health, and leave via the gift shop for some excellent rainbow merch.

2 Granary Square, N1C 4BH
Nearest station: King's Cross St. Pancras
Free entry
queerbritain.org.uk

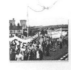

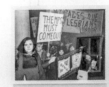

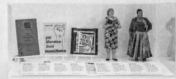

51

2 WILLOW ROAD

Modernist architect's Hampstead home

He may be best known for his residential tower blocks, but when it came to designing his own home, Ernő Goldfinger preferred the discretion of a mid-terrace – albeit one that is totally unique. One of Britain's two Modernist homes open to the public, 2 Willow Road offers a special insight into Goldfinger's creative philosophy and innovative designs. Completed in 1939, the building lacks the exterior impact of the architect's iconic high-rises, but generously compensates with its moveable walls, enviable art collection and a convincing interior reconstruction that will have you believing the man himself might return any second (but don't worry if he doesn't – the tour guides are just as knowledgeable).

2 Willow Road, NW3 1TH
Nearest station: Hampstead Heath
Paid entry
nationaltrust.org.uk

IMAGE CREDITS

An Opinionated Guide to London Museums
First edition
Published in 2024 by Hoxton Mini Press, London
Copyright © Hoxton Mini Press 2024. All rights reserved.

Text by Emmy Watts
Copy-editing by Florence Ward
Additional design by Richard Mason
Proofreading by Octavia Stocker
Production and editorial support by Megan Baffoe
With thanks to Matthew Young for initial series design.

Please note: we recommend checking the websites listed for each
entry before you visit for the latest information on price, opening times
and pre-booking requirements.

A CIP catalogue record for this book is available from the British Library.
ISBN: 978-1-914314-54-4
Printed and bound by OZGraf, Poland

Hoxton Mini Press is an environmentally conscious publisher, committed
to offsetting our carbon footprint. This book is 100 per cent carbon
compensated, with offset purchased from Stand For Trees.

For every book you buy from our website, we plant a tree:
www.hoxtonminipress.com

INDEX